Yoga Spirit

Timna Green

Copyright © 2016 Timna Green

All rights reserved.

ISBN-13:

978-1540664969

ISBN-10:

1540664961

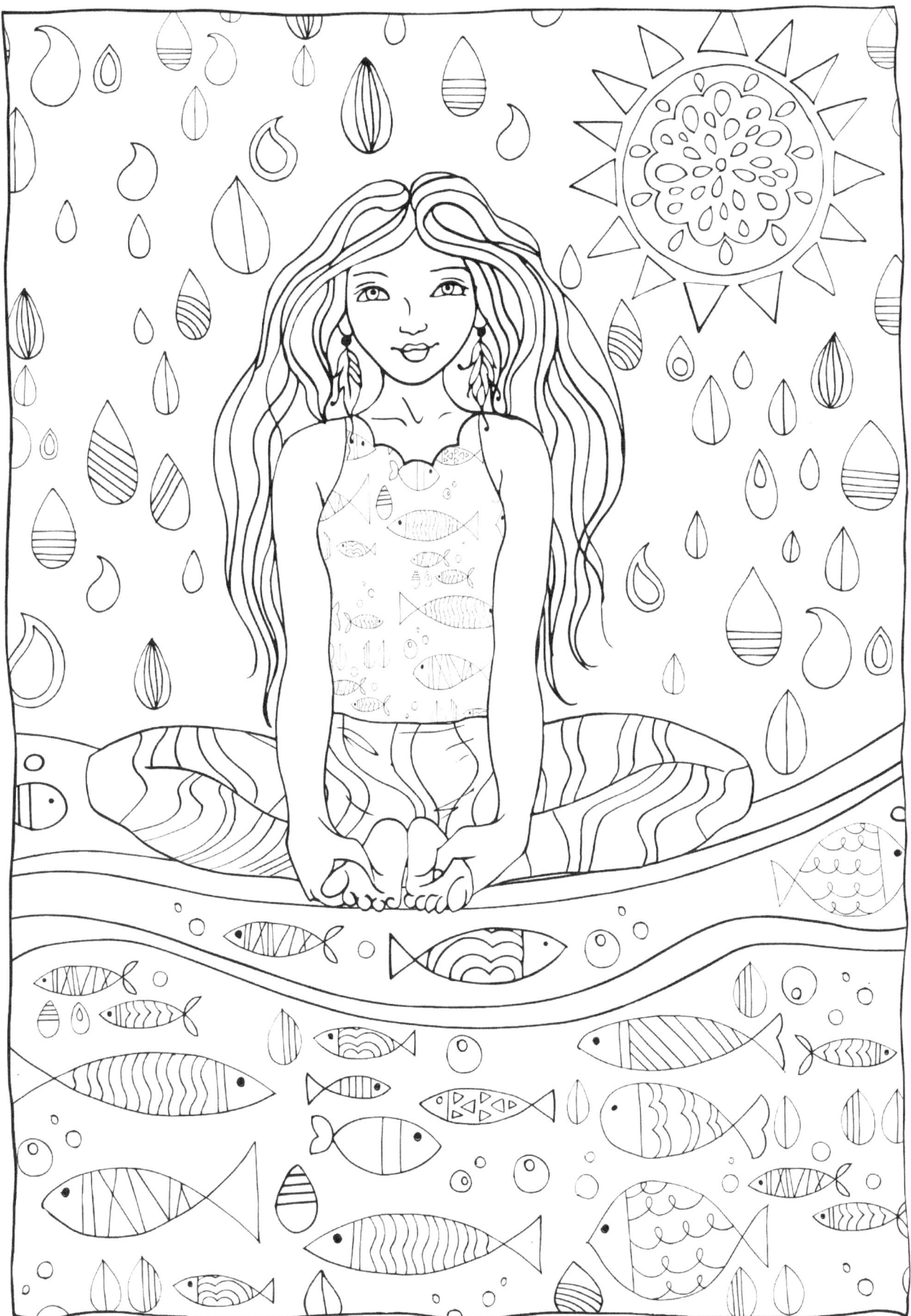

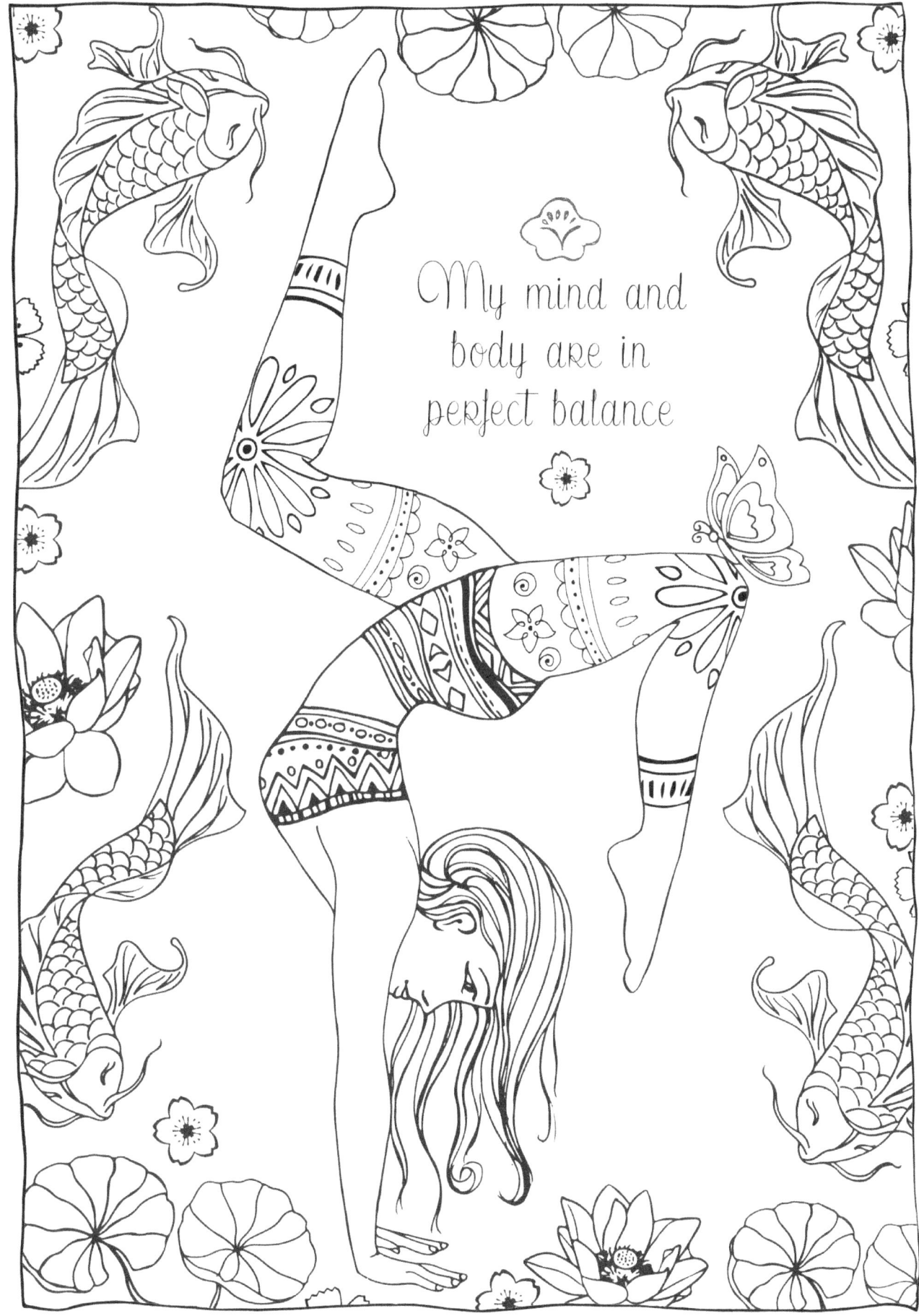

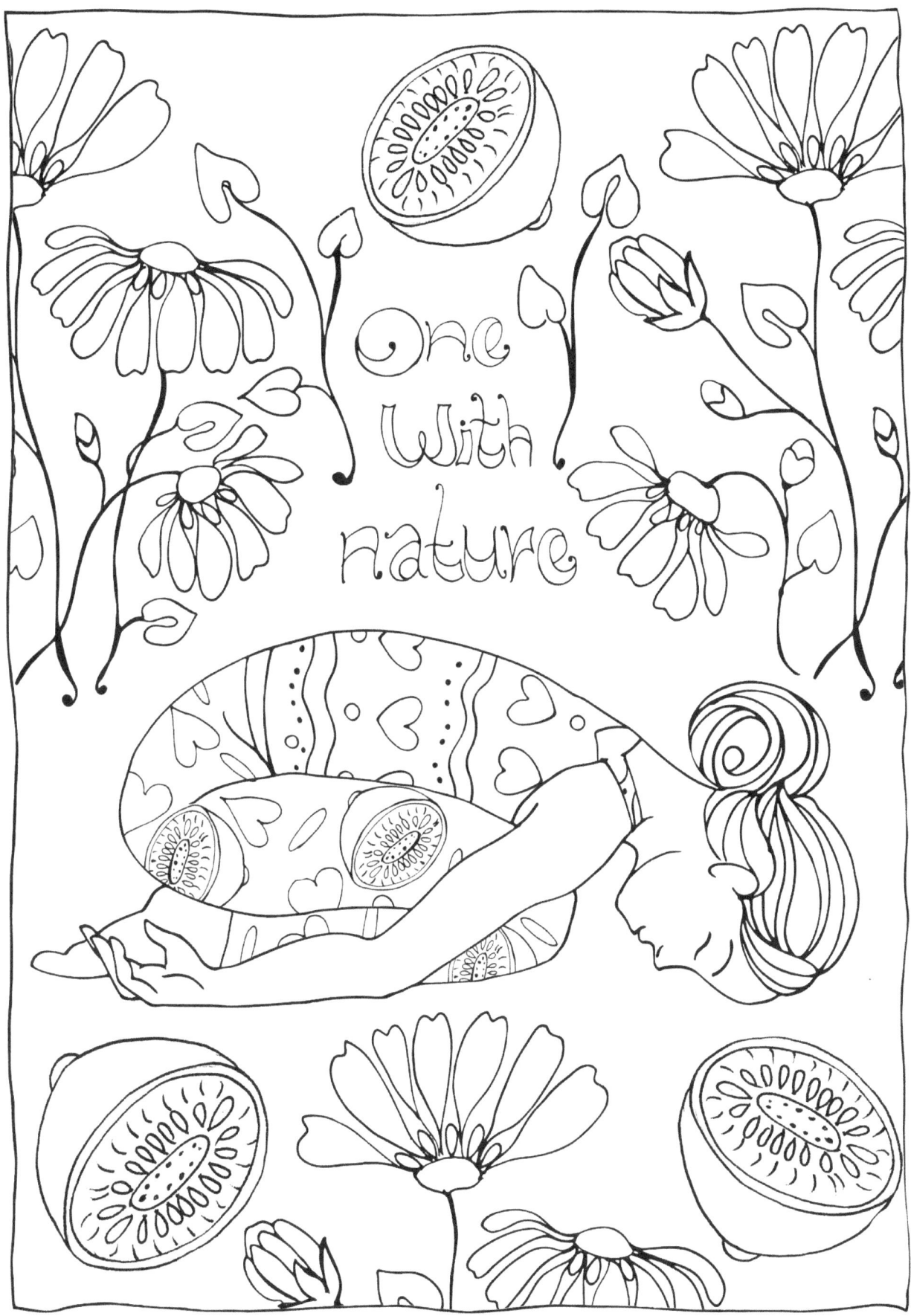

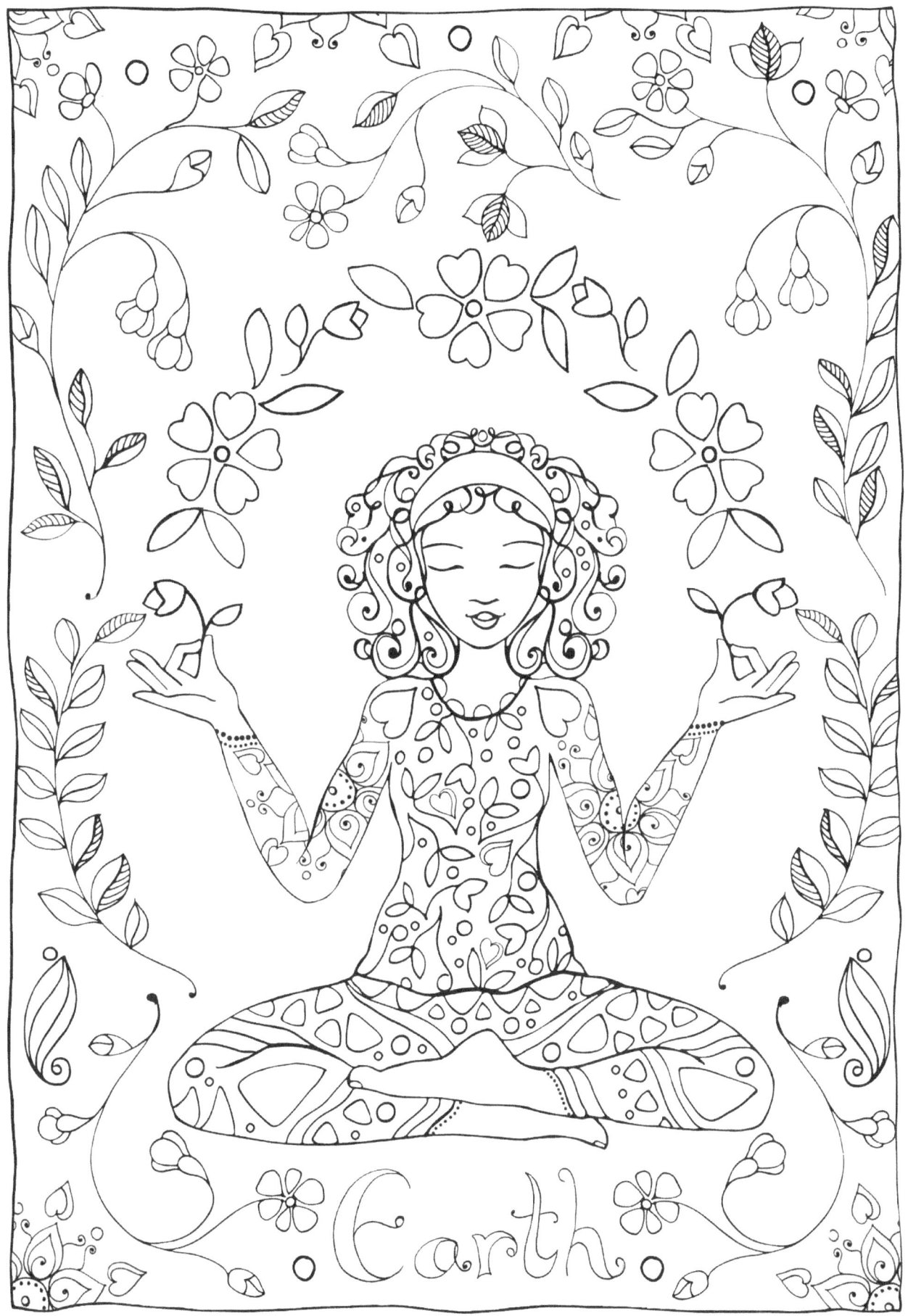

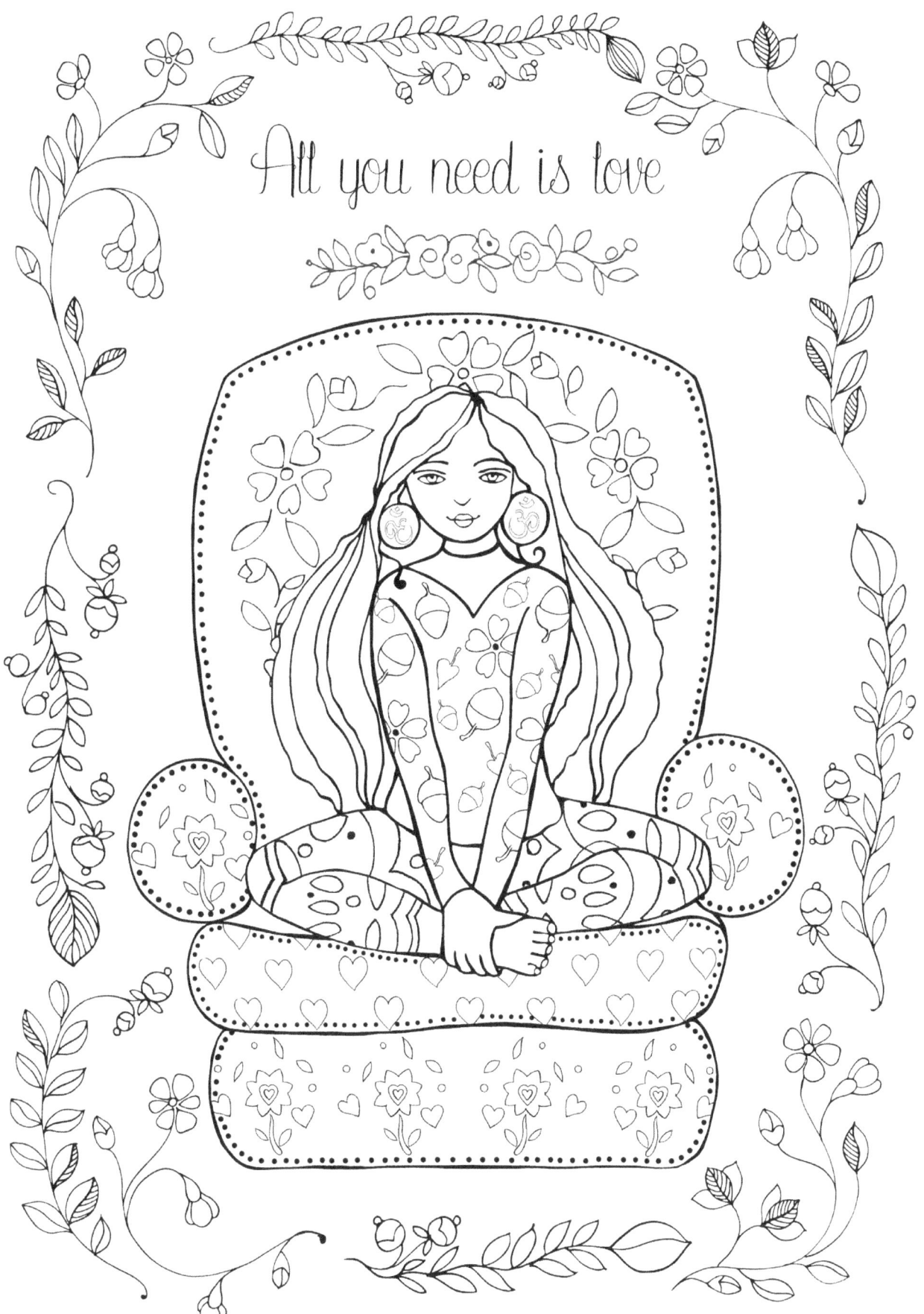

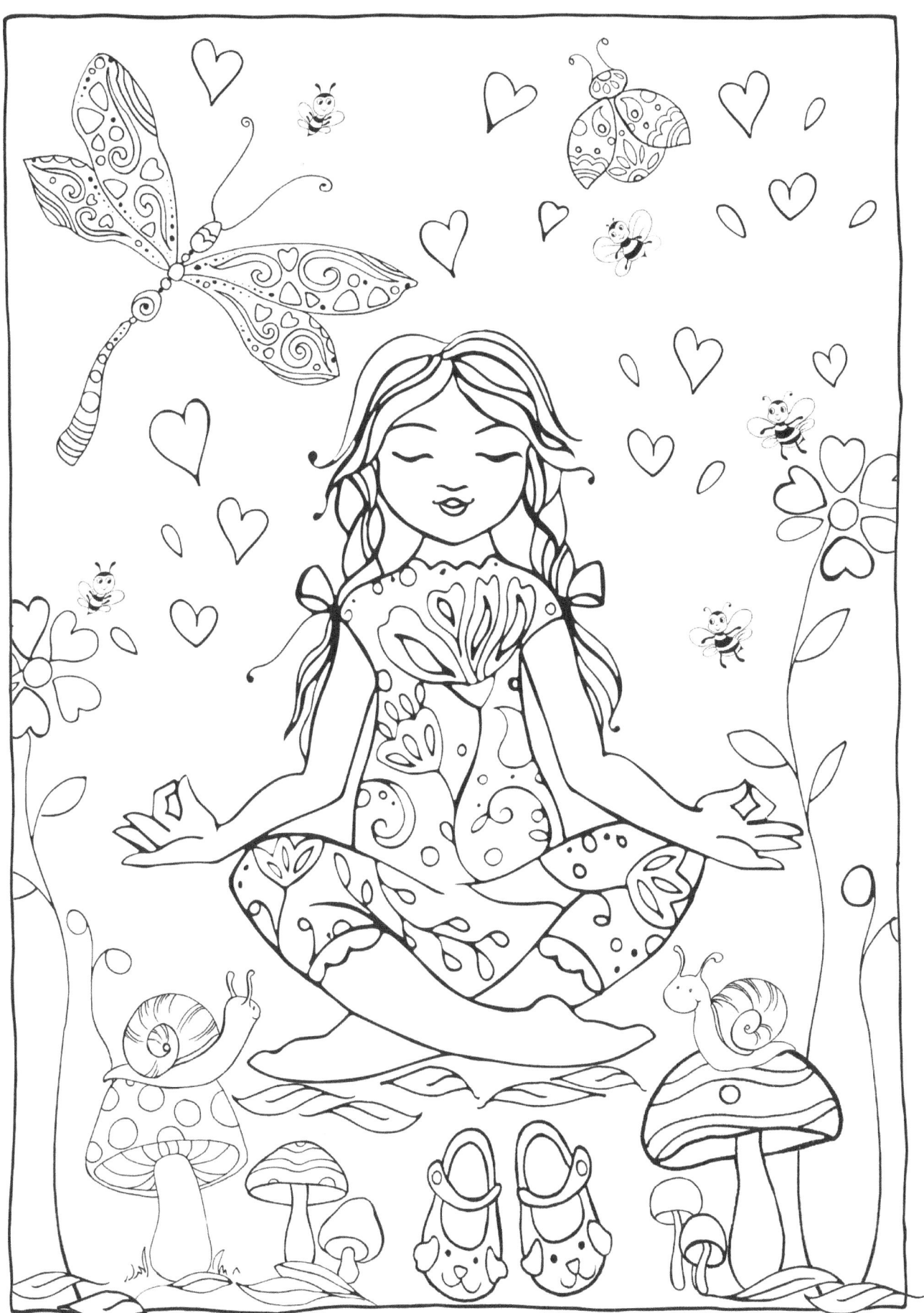

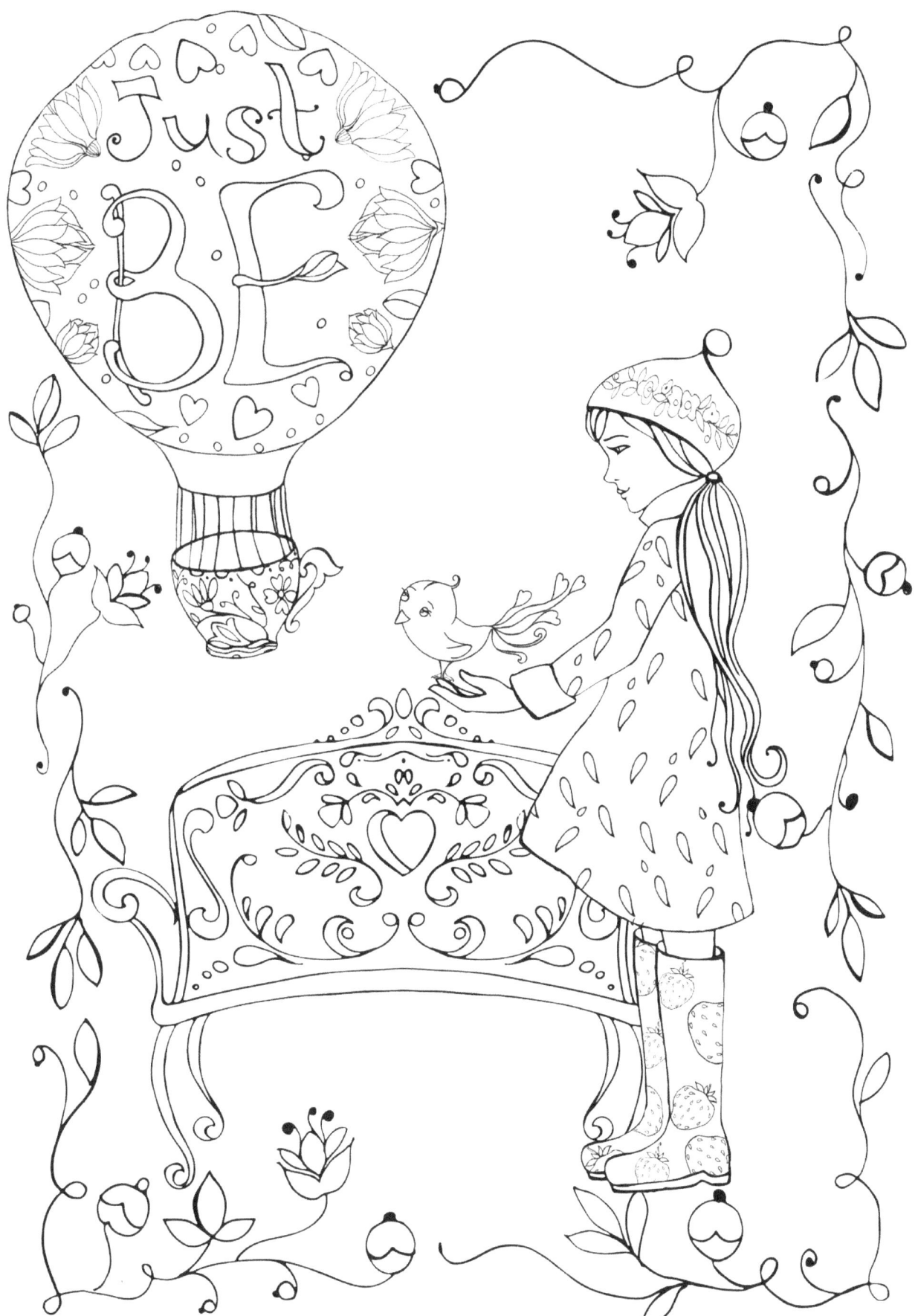

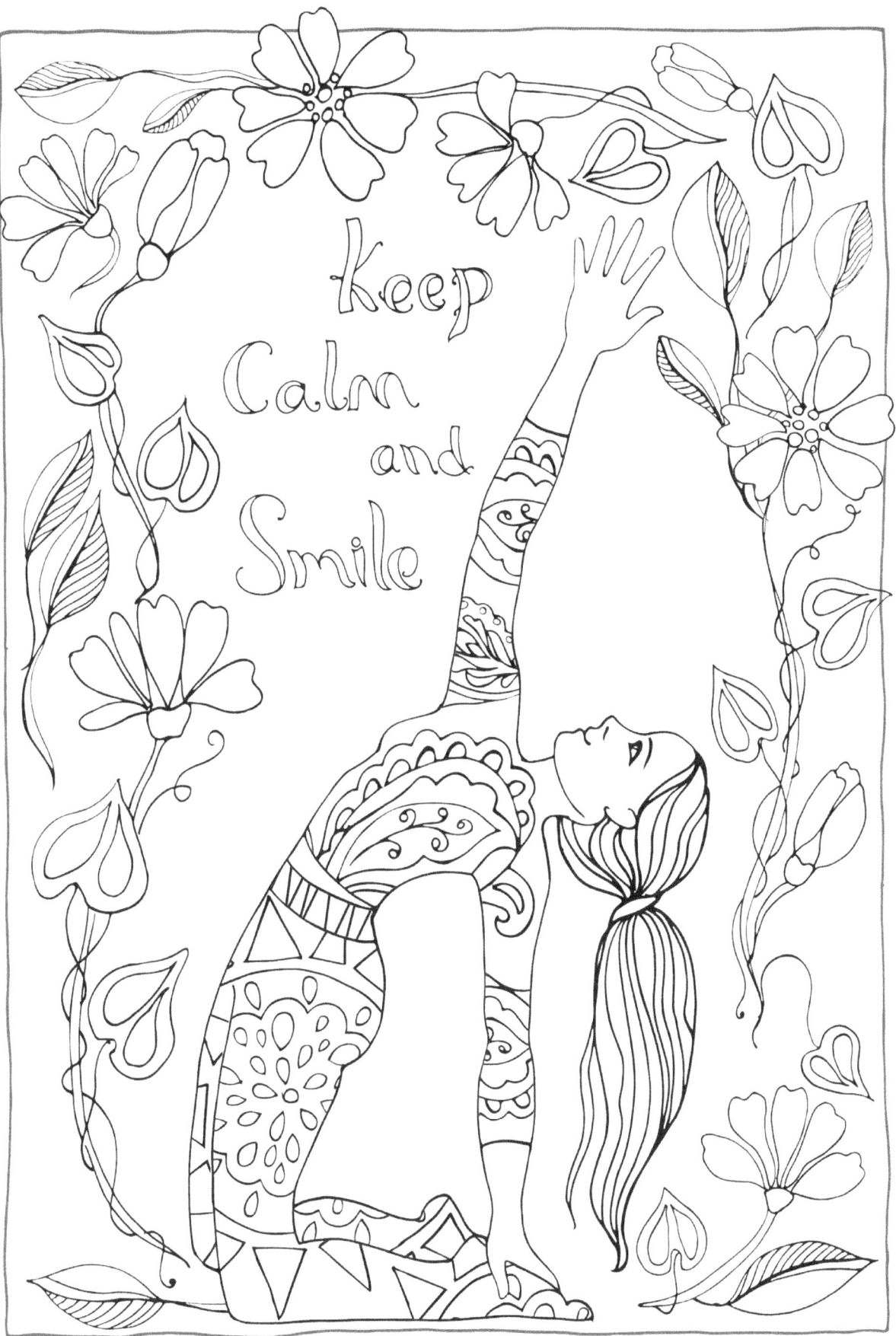

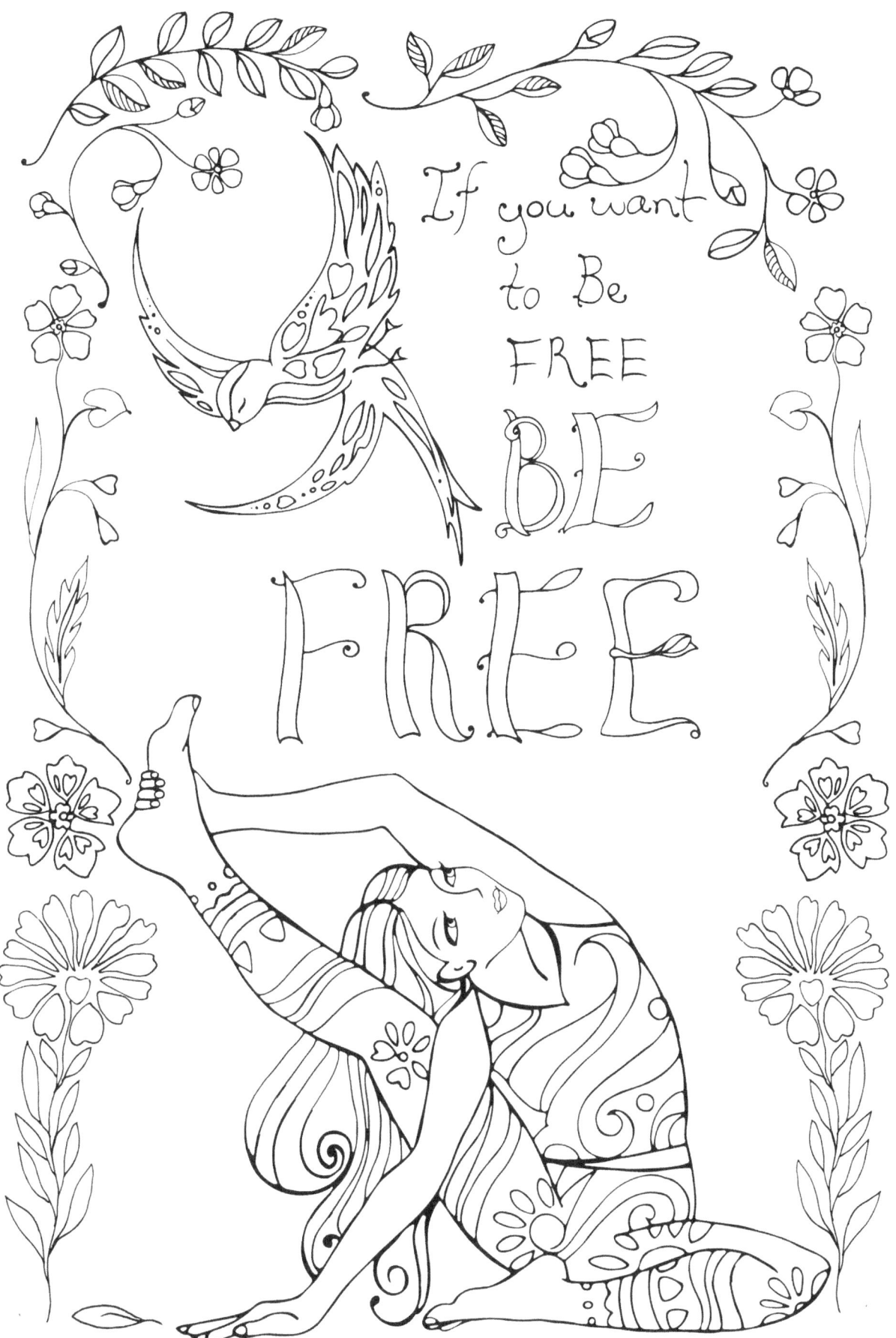

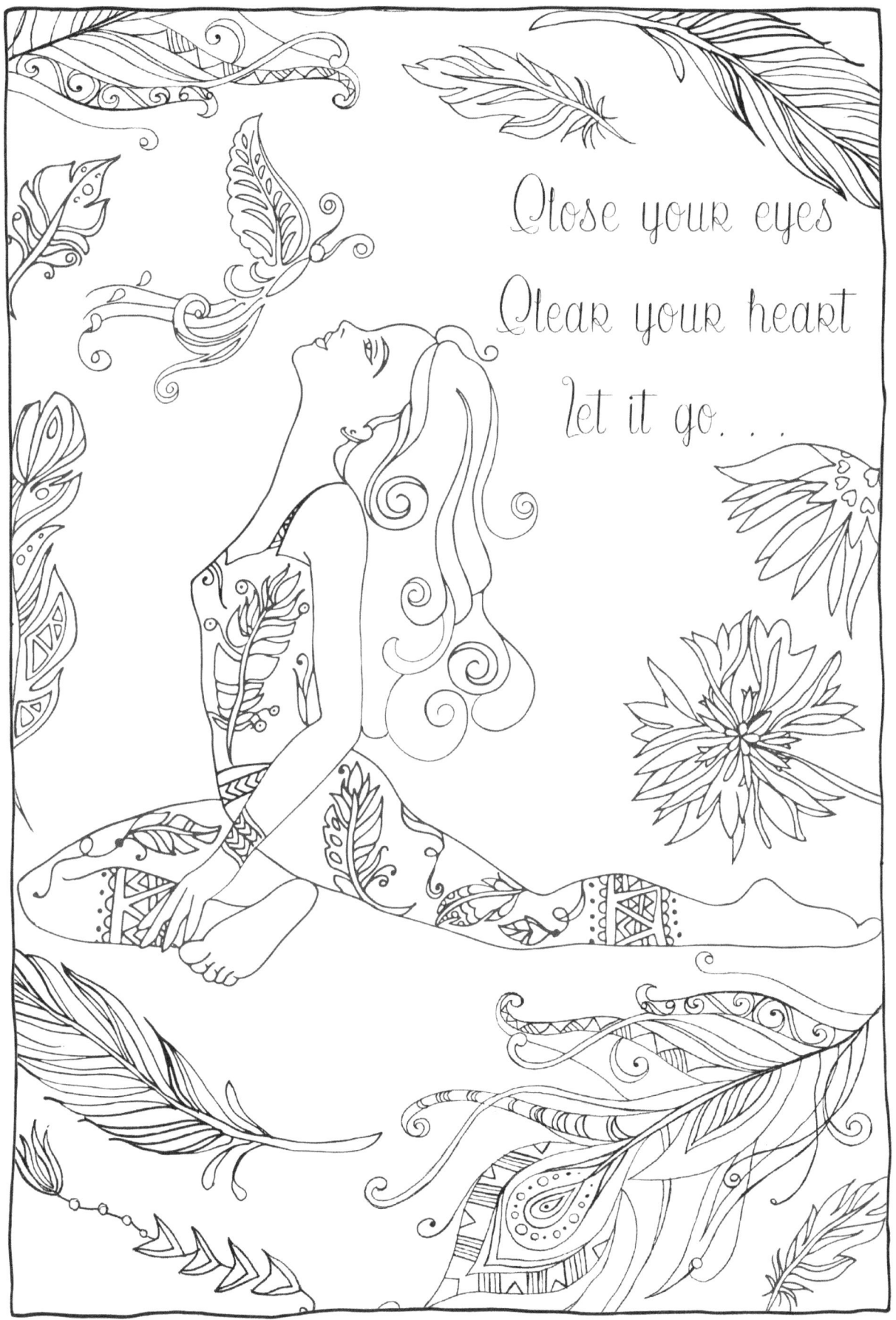

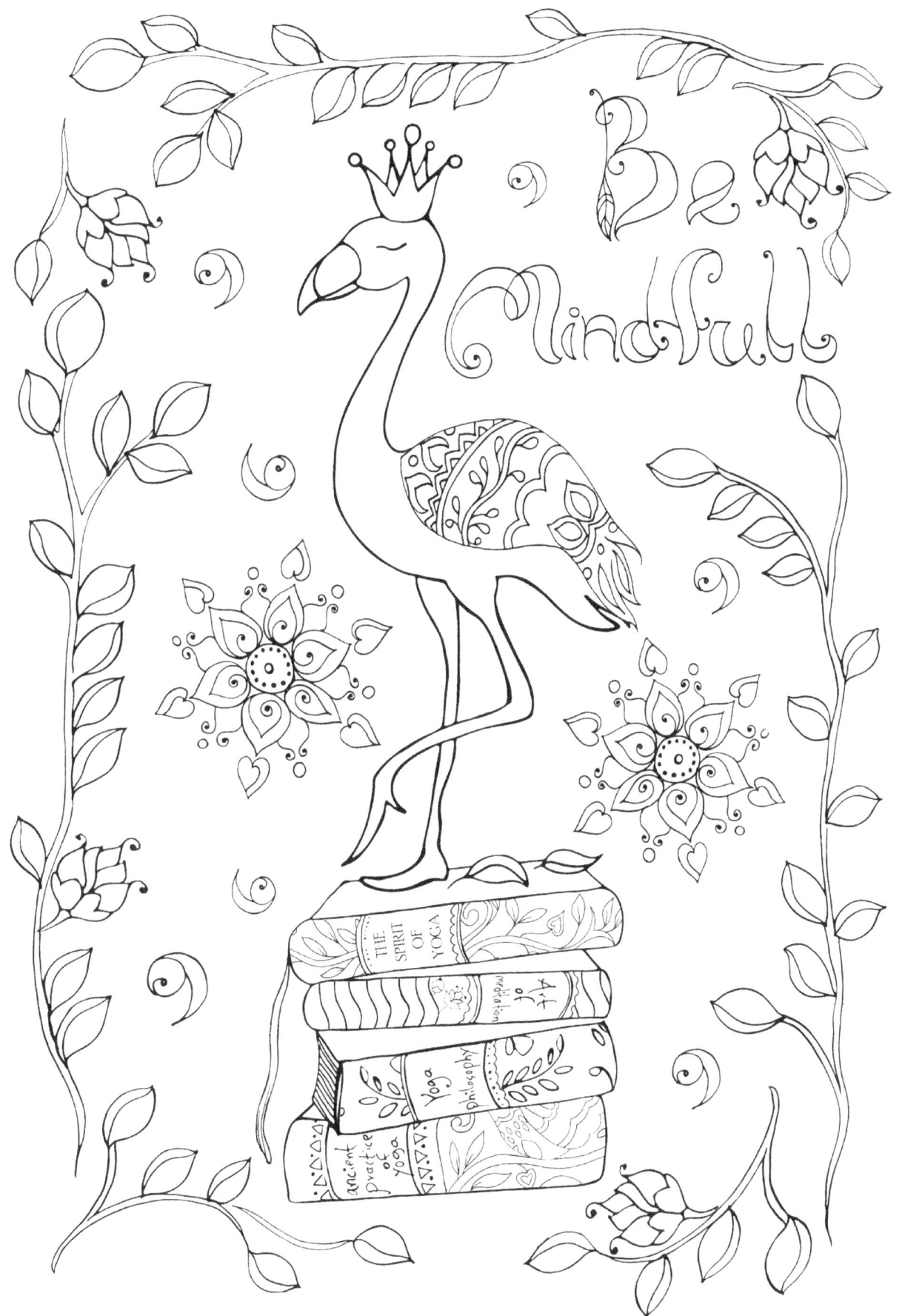

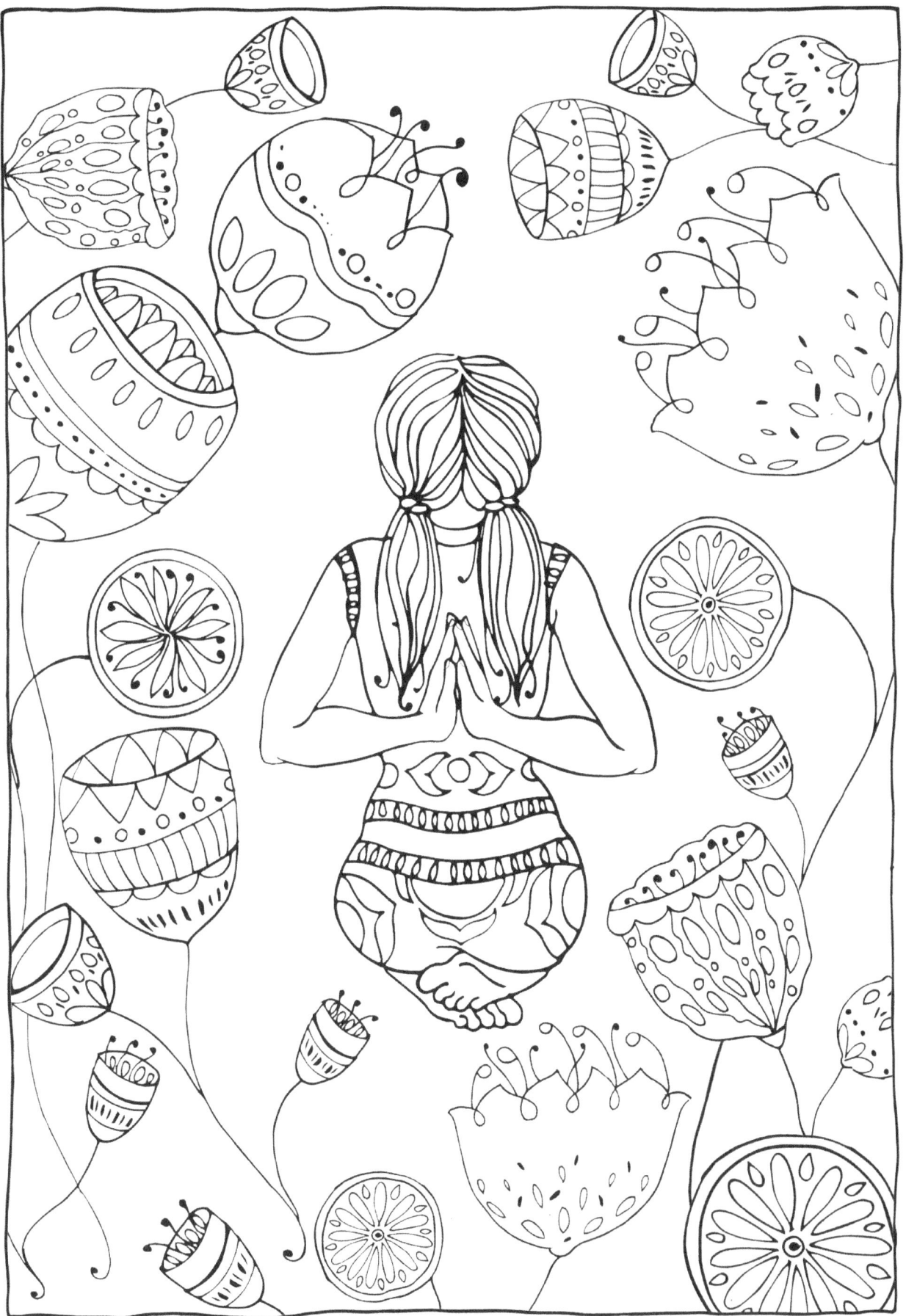

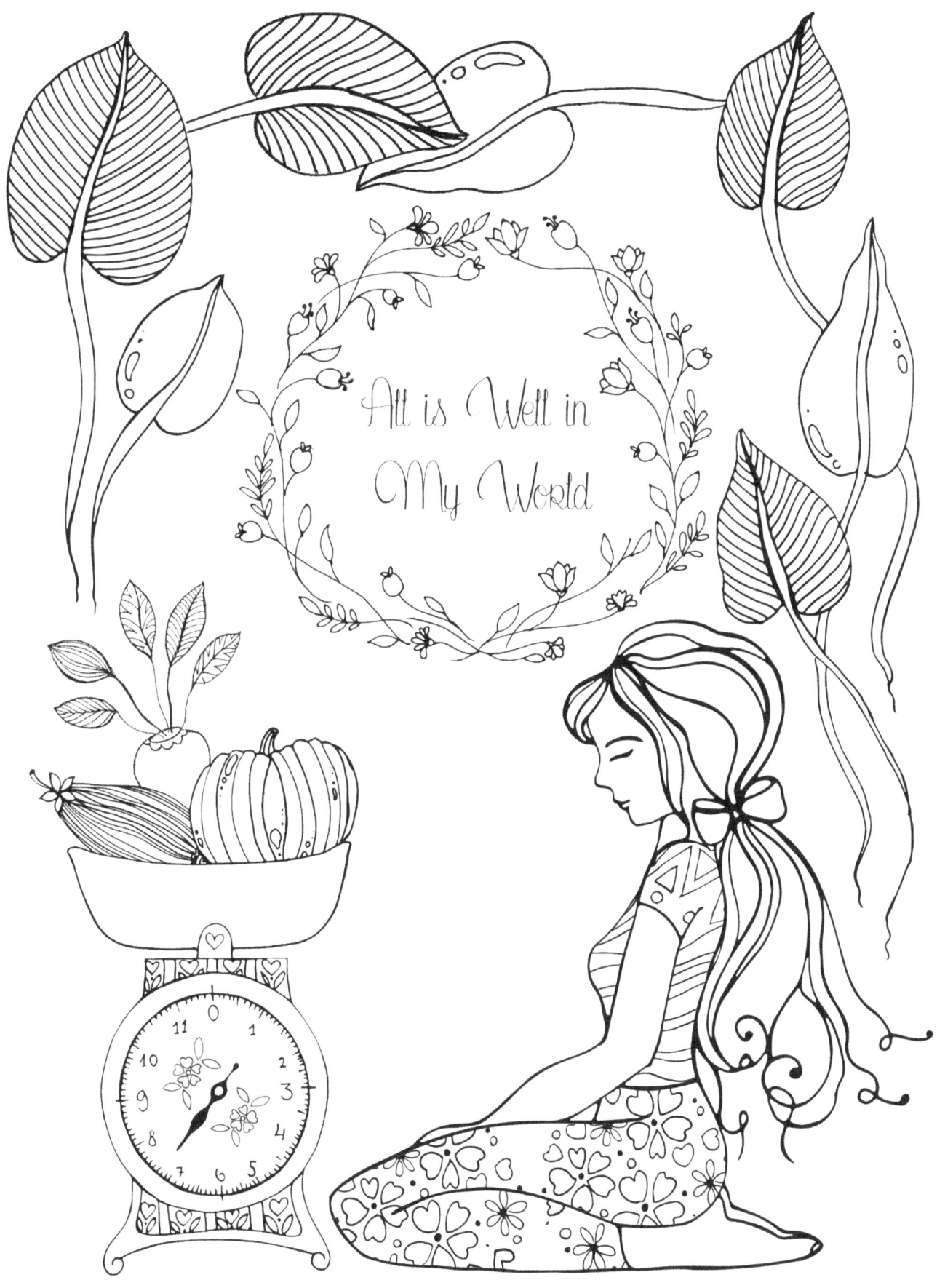

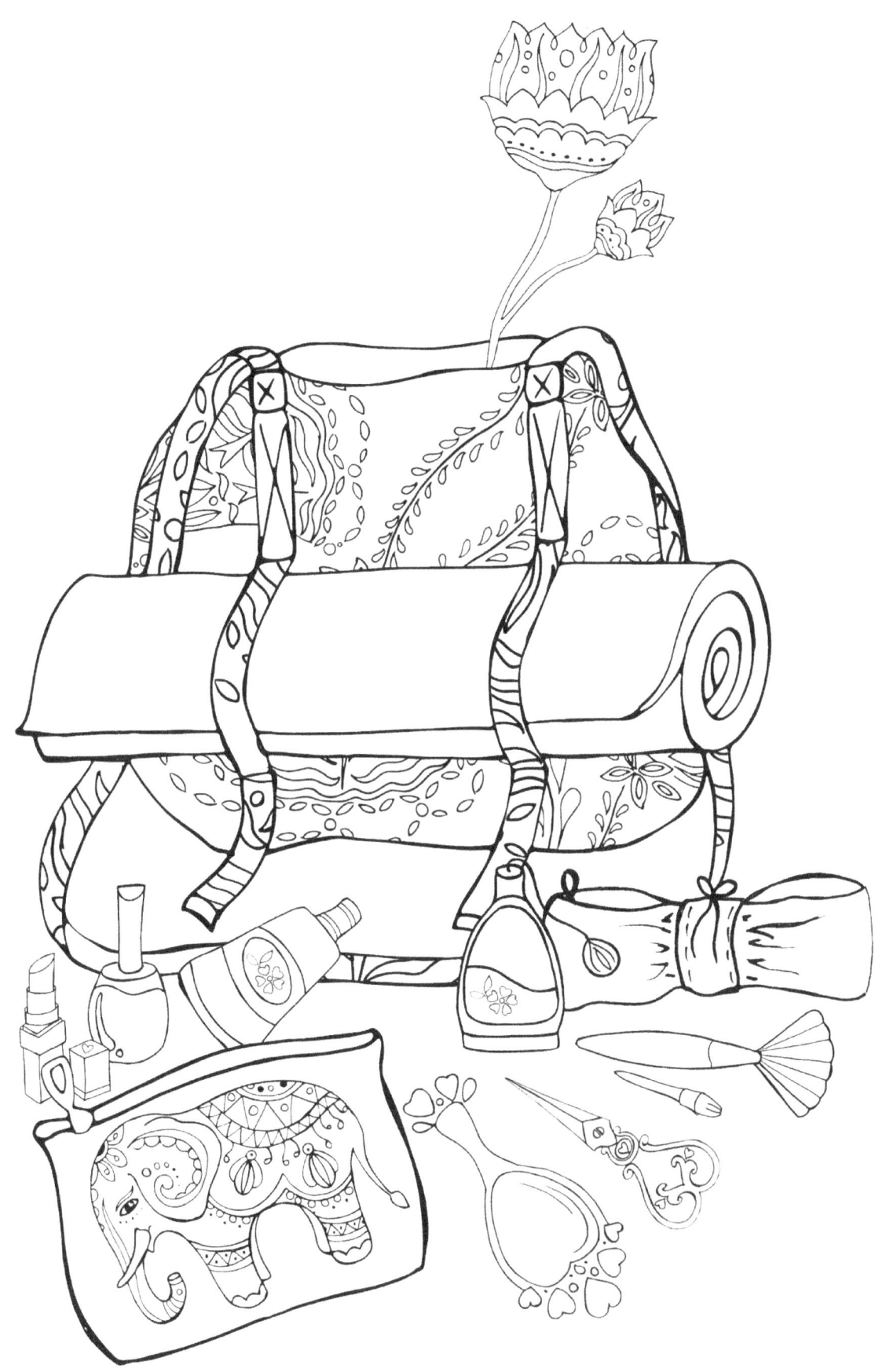

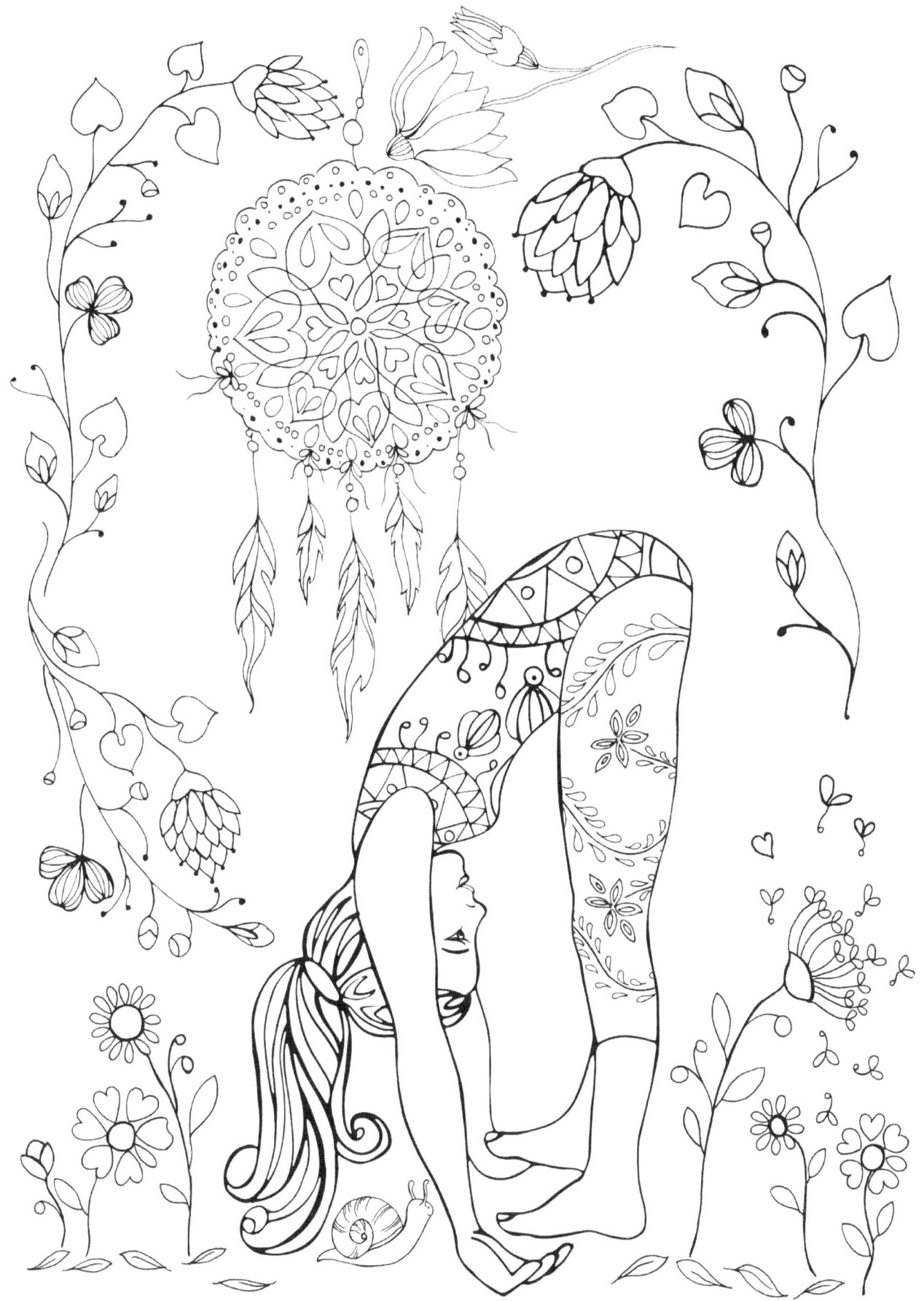

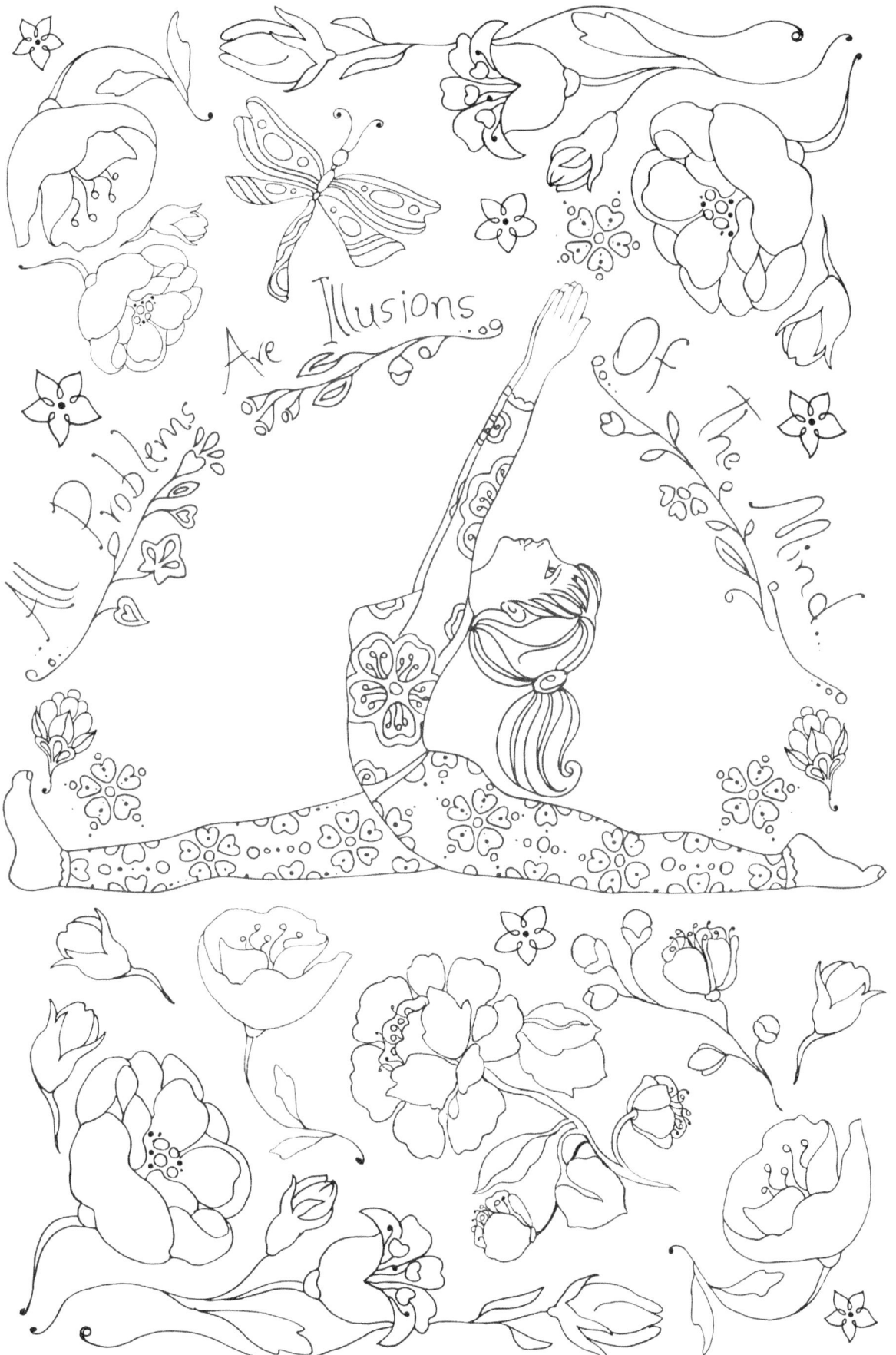

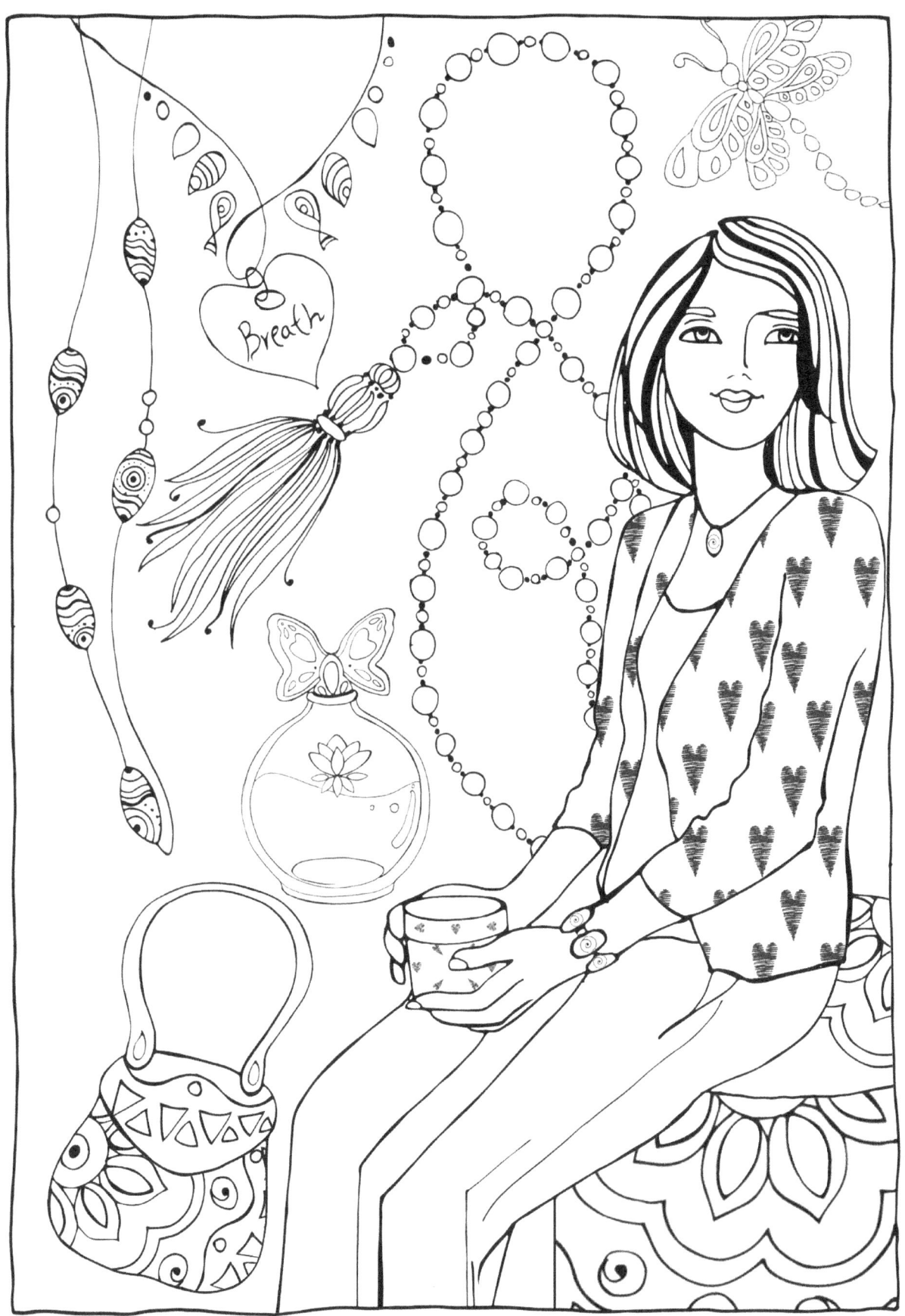

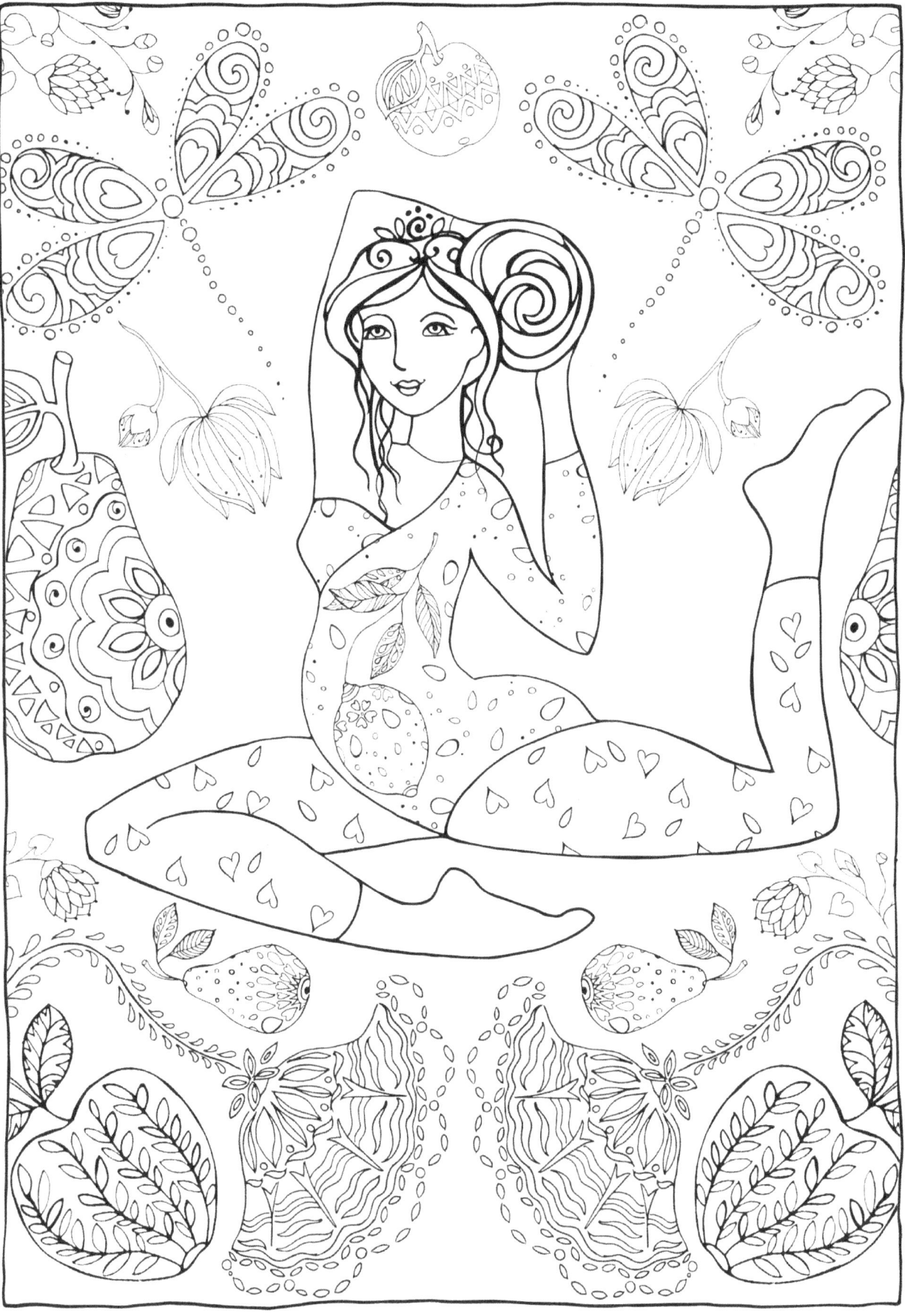

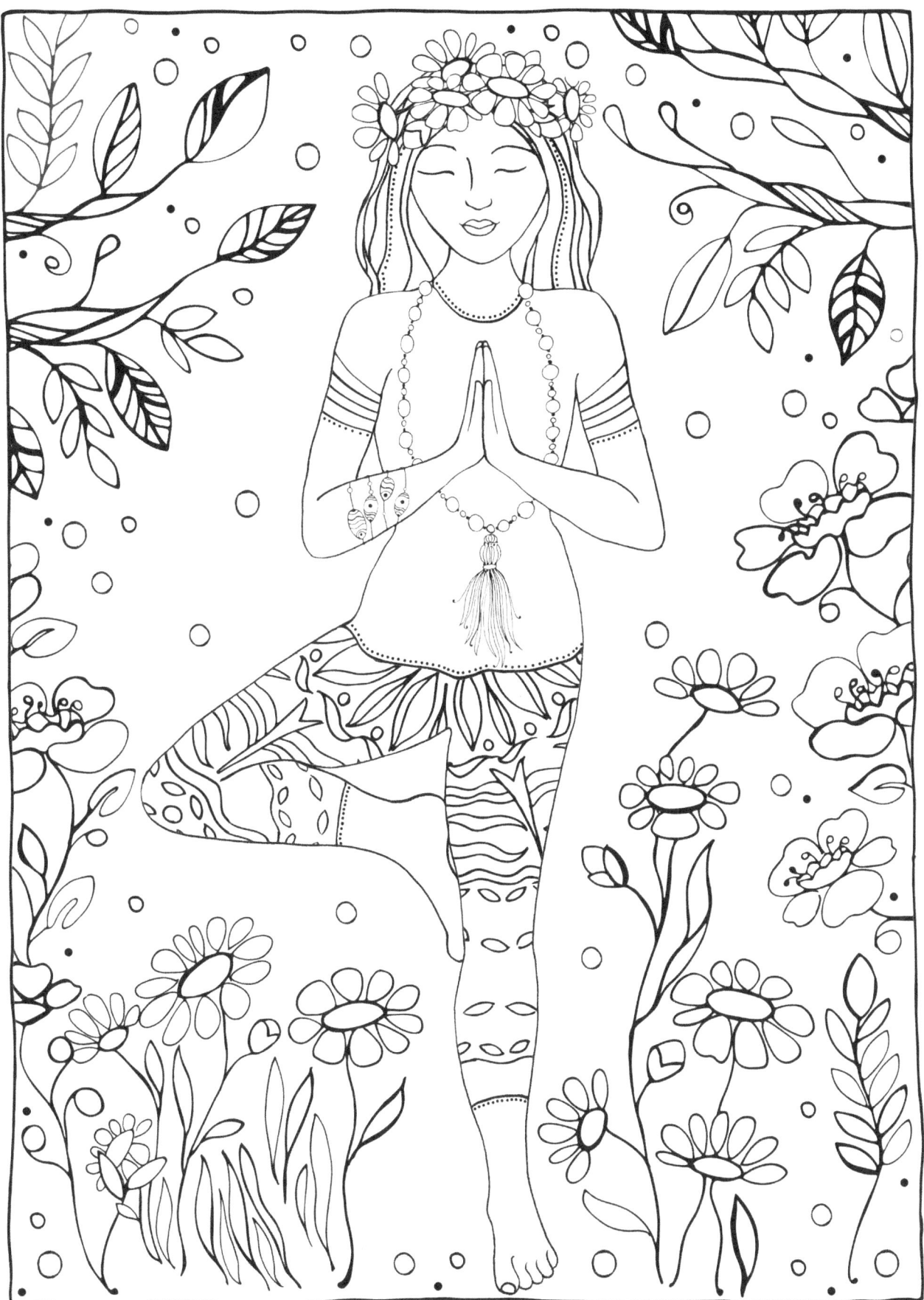

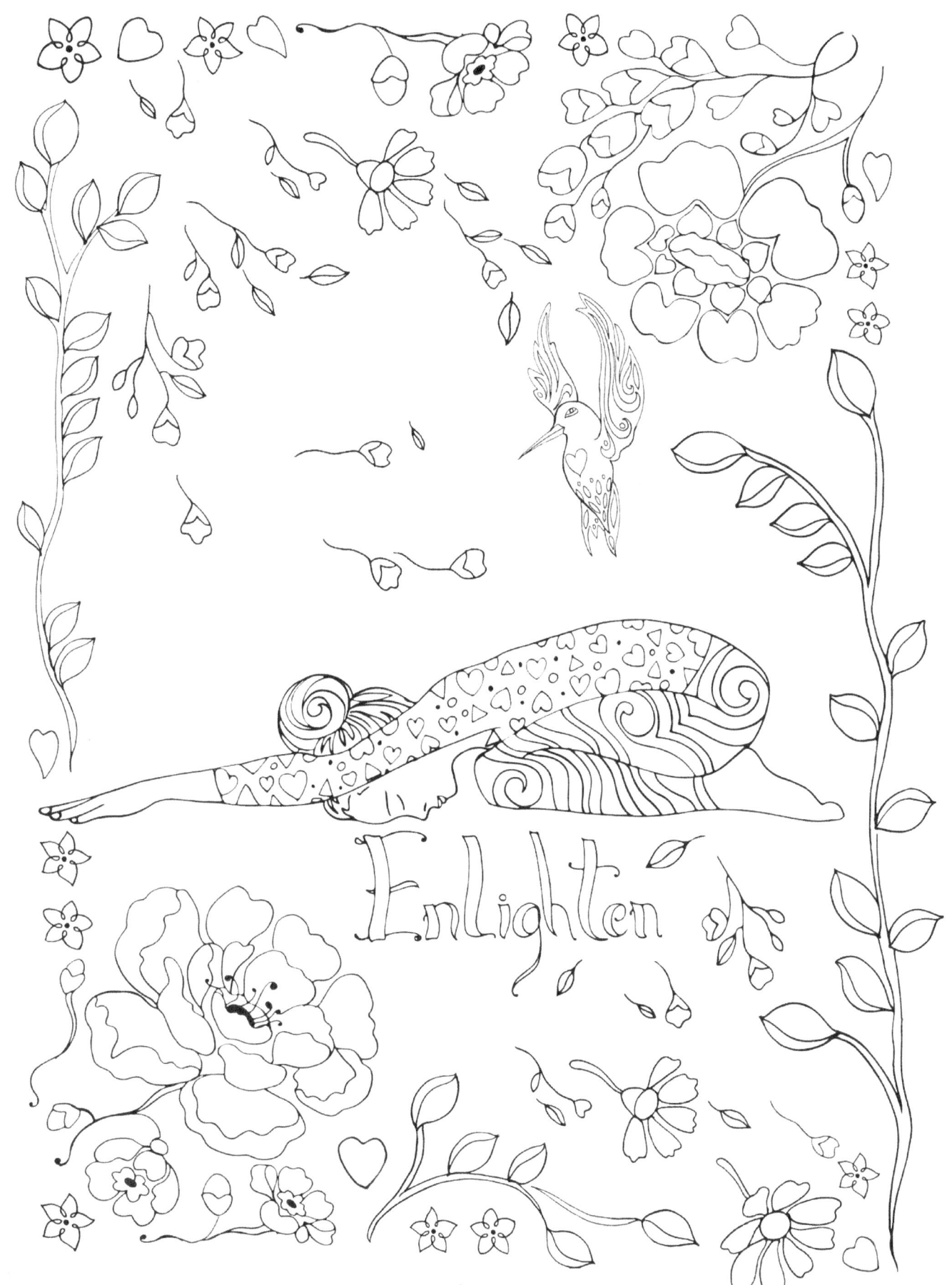

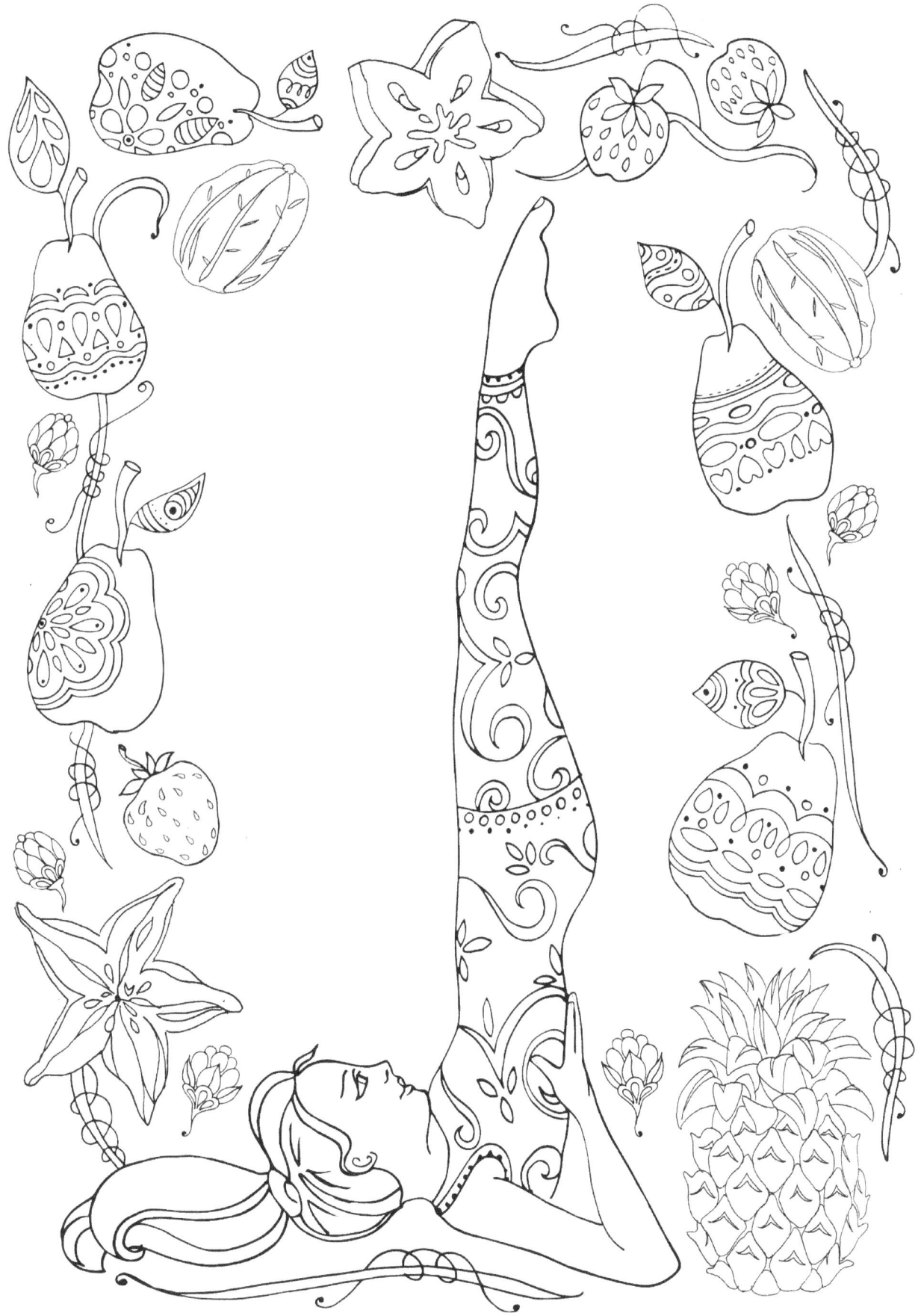

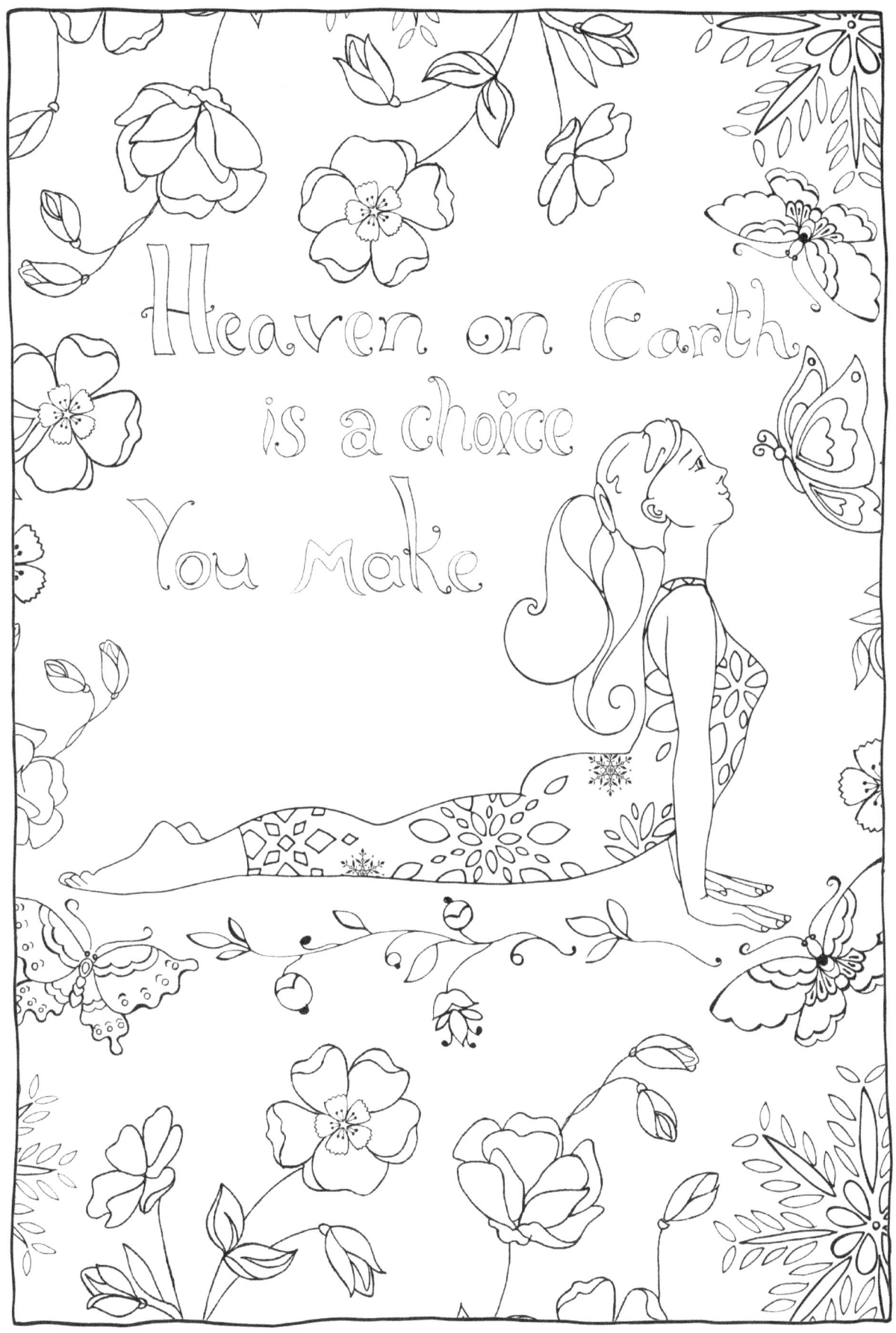

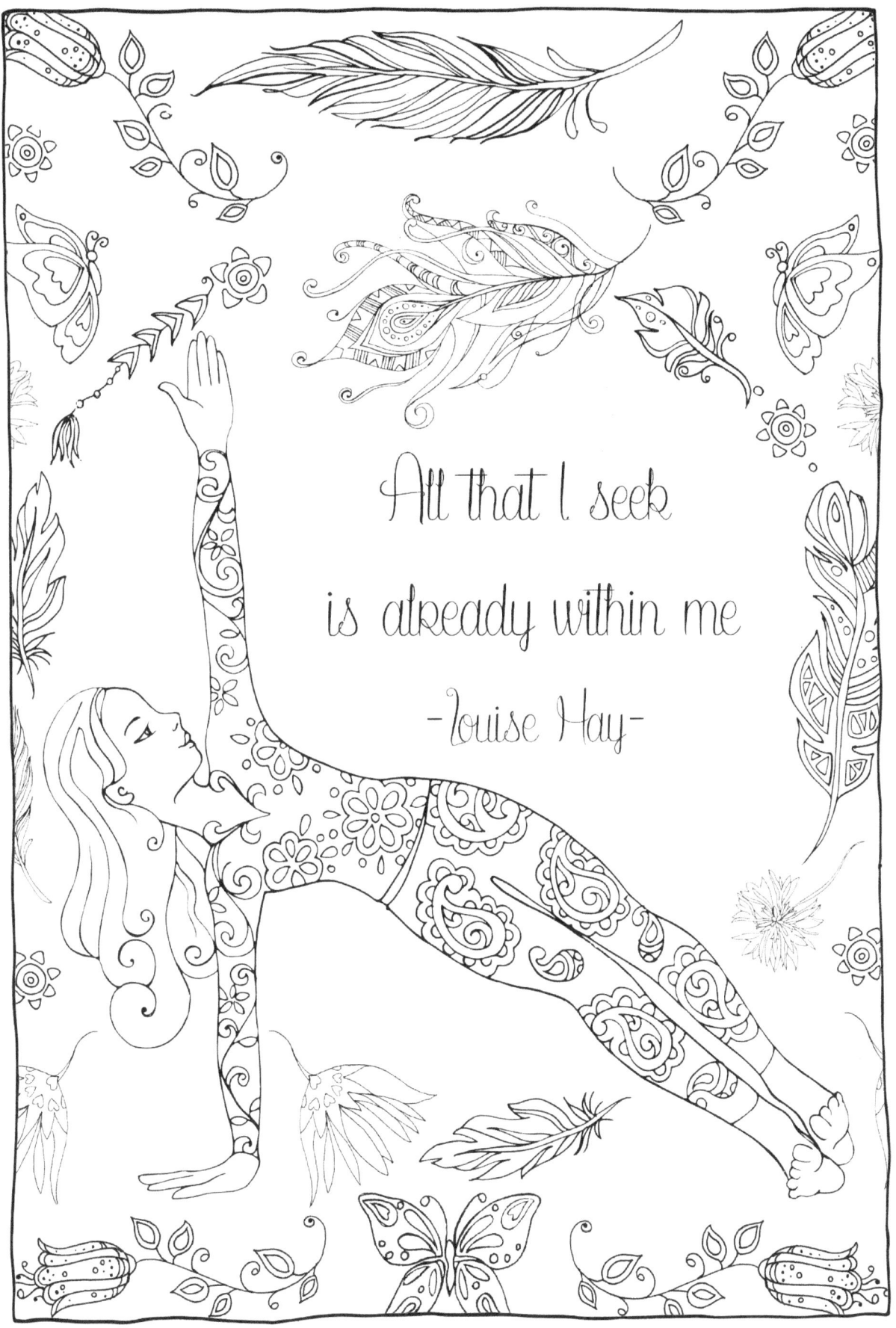

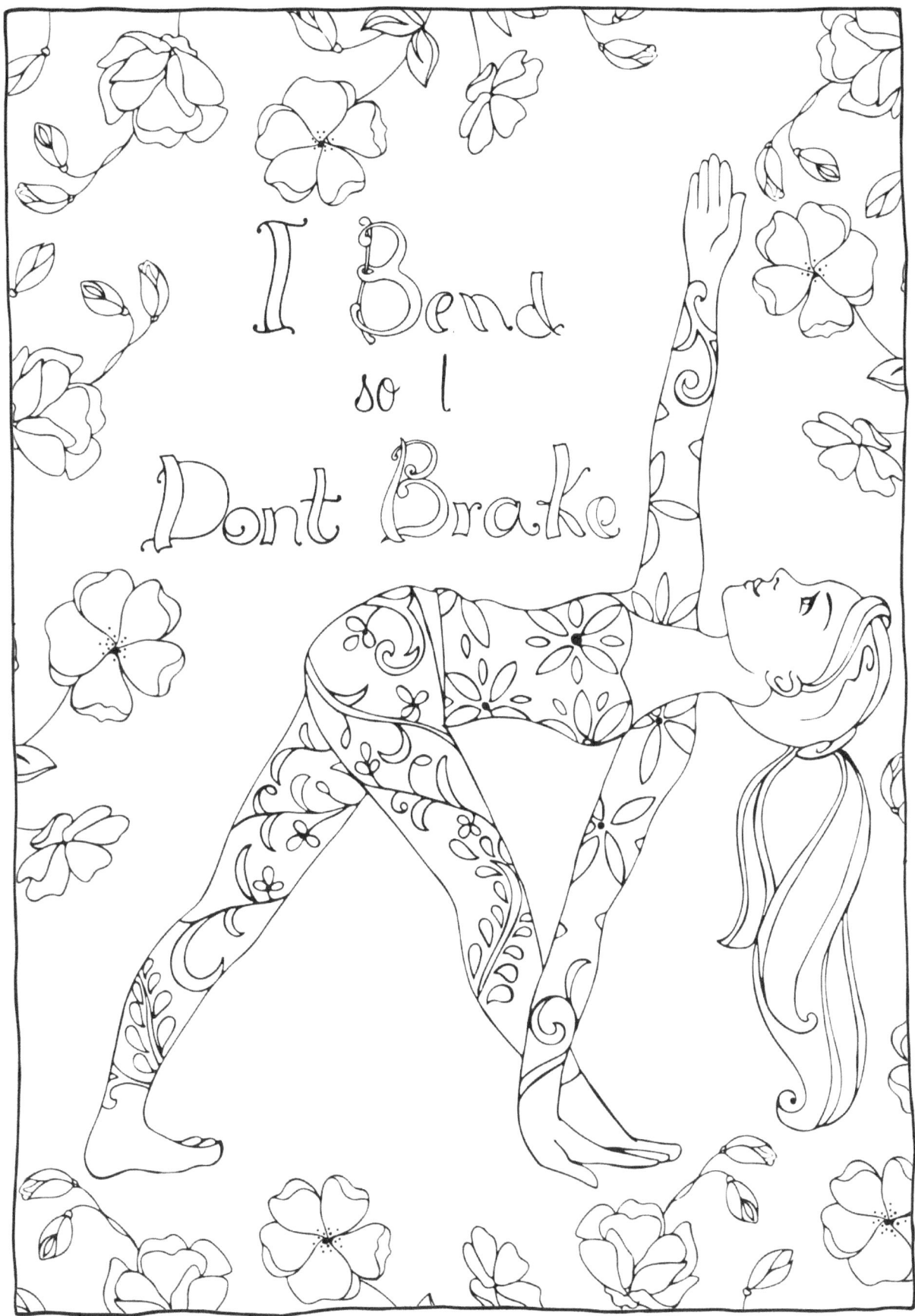

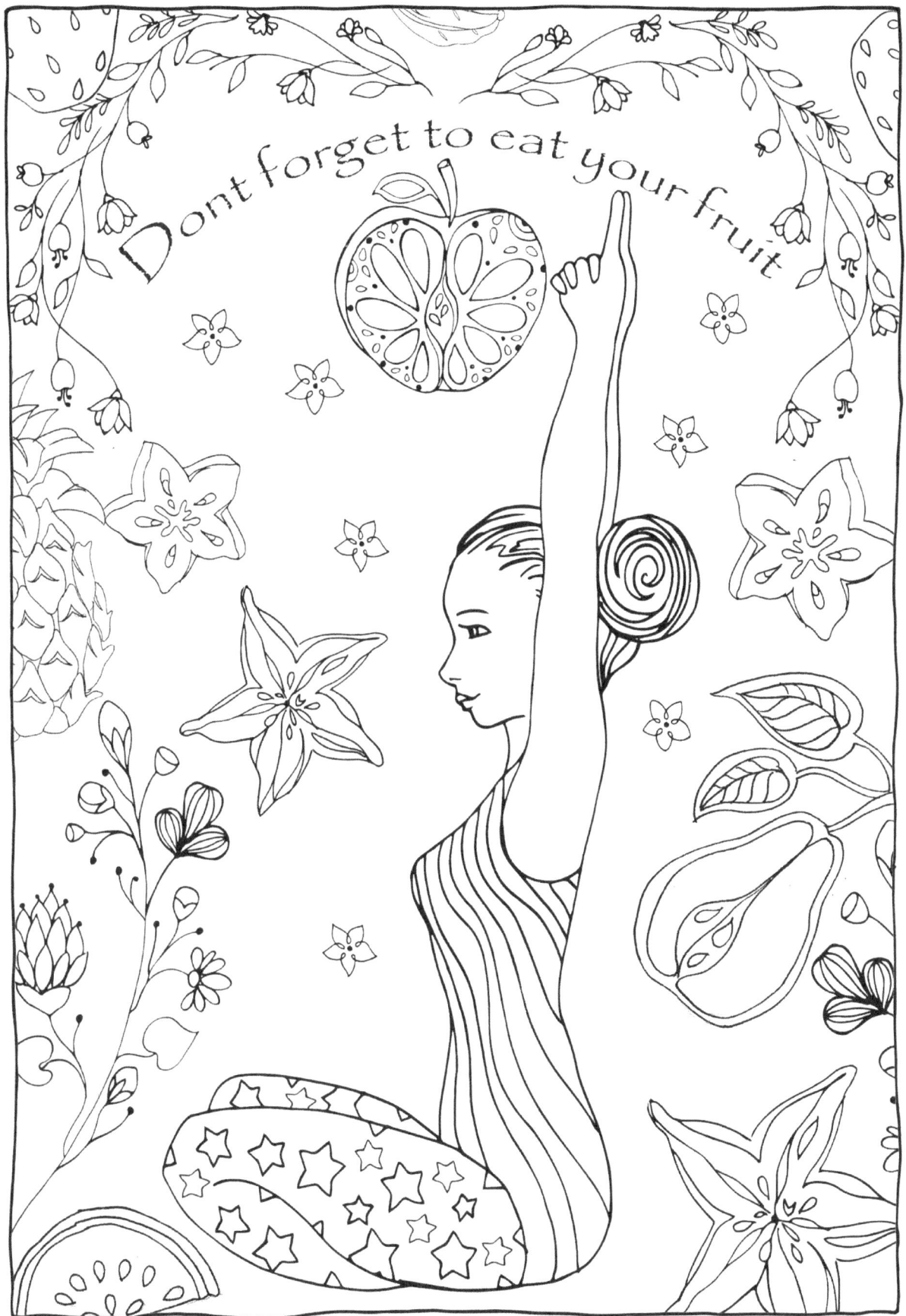

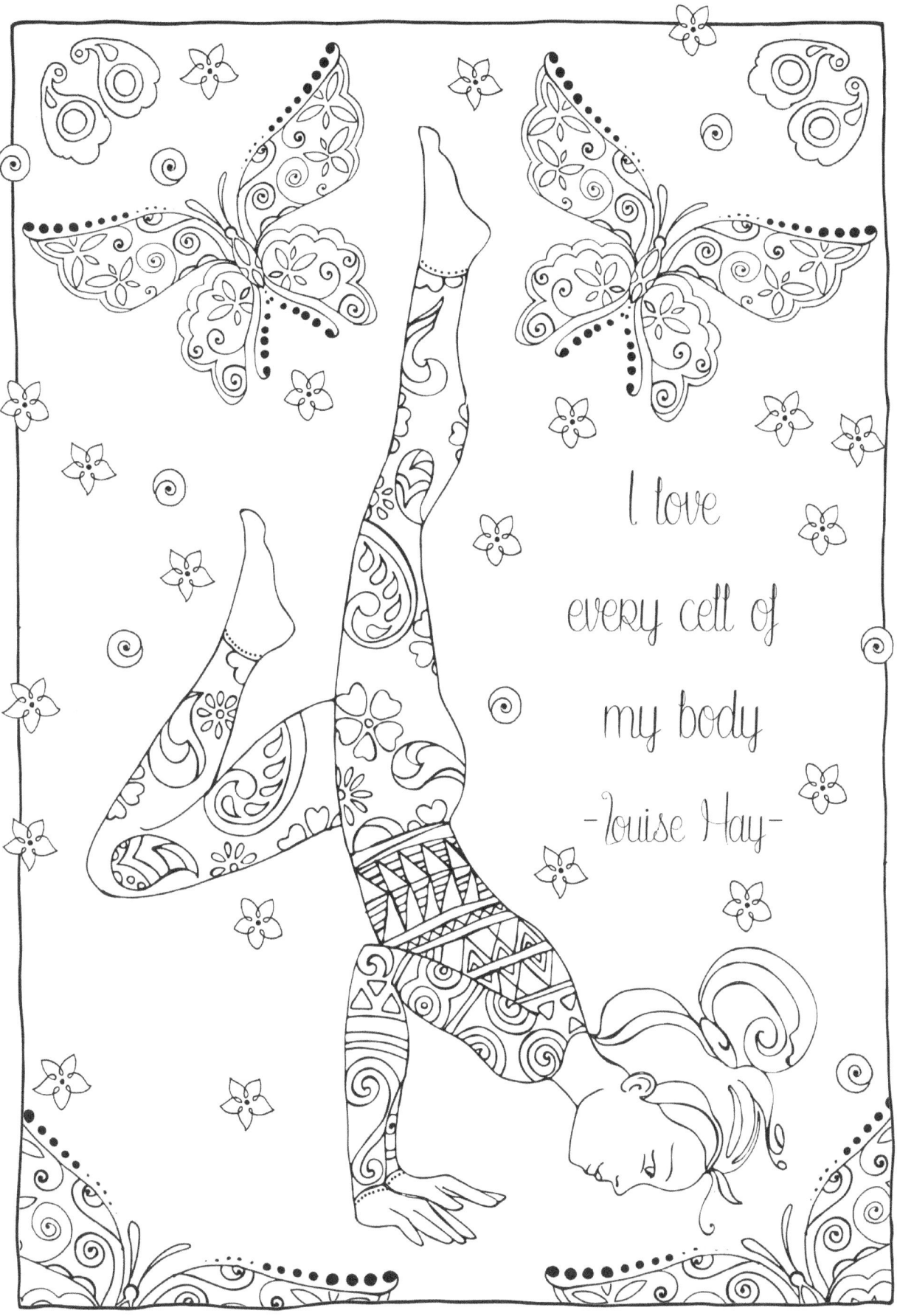

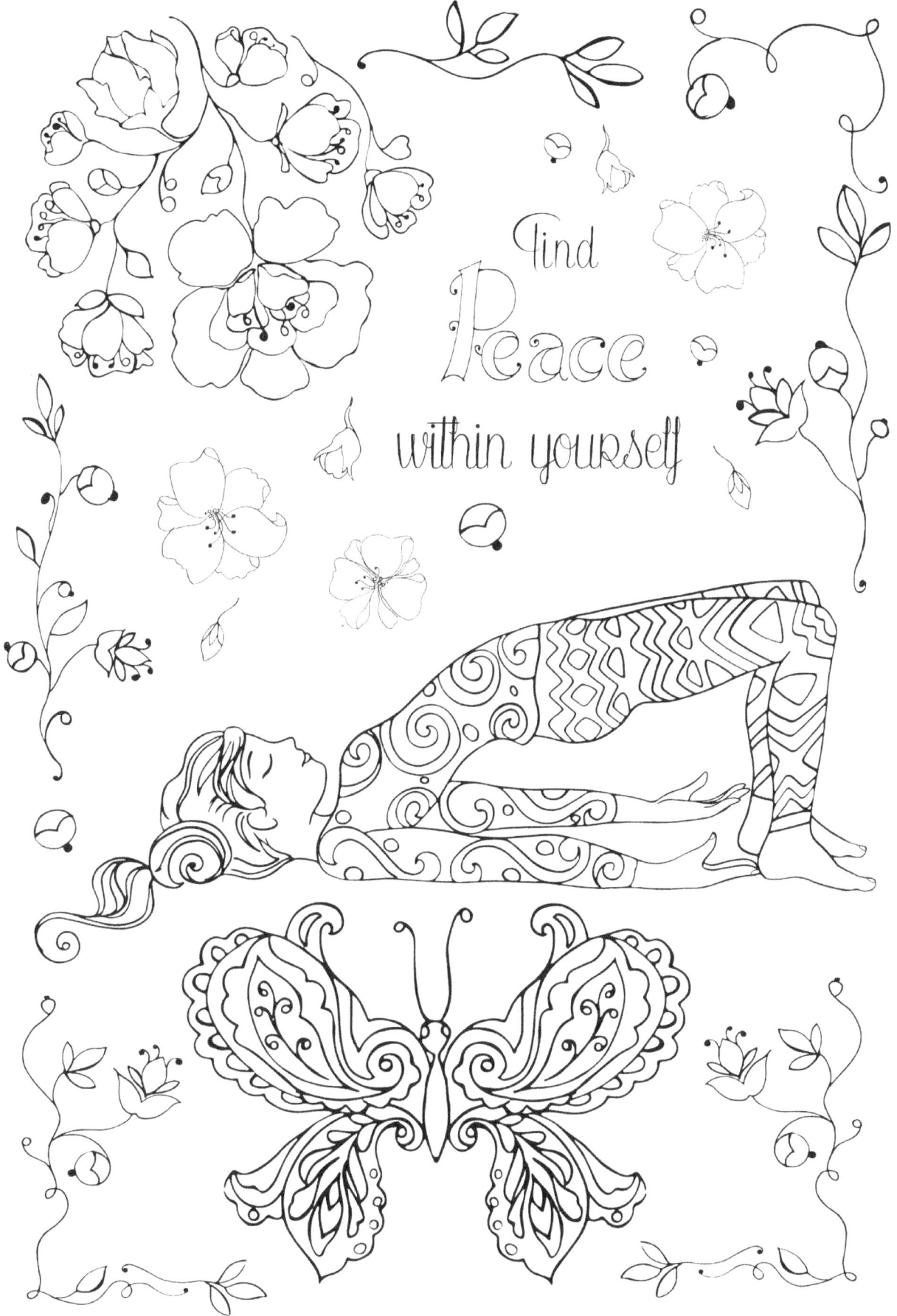

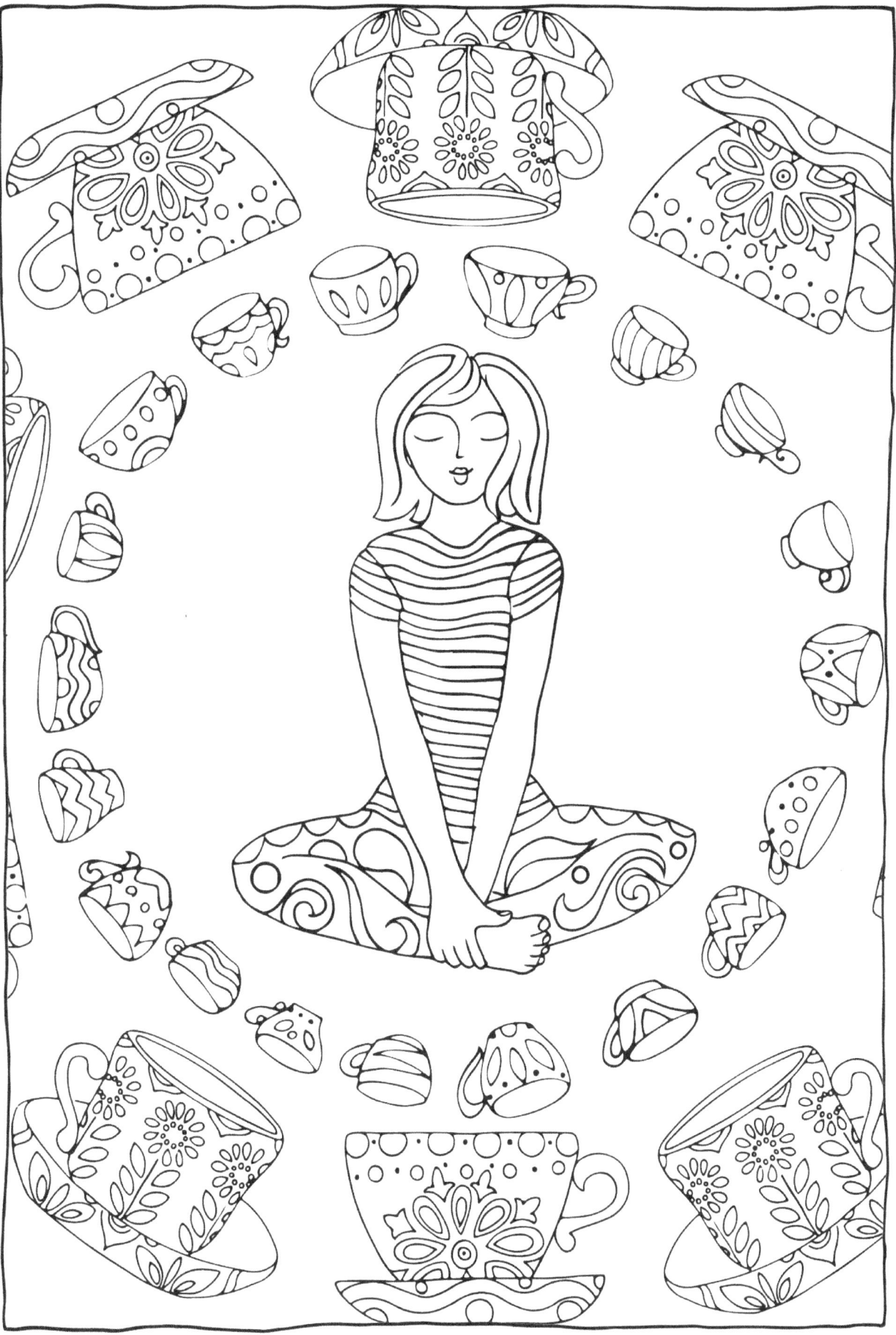

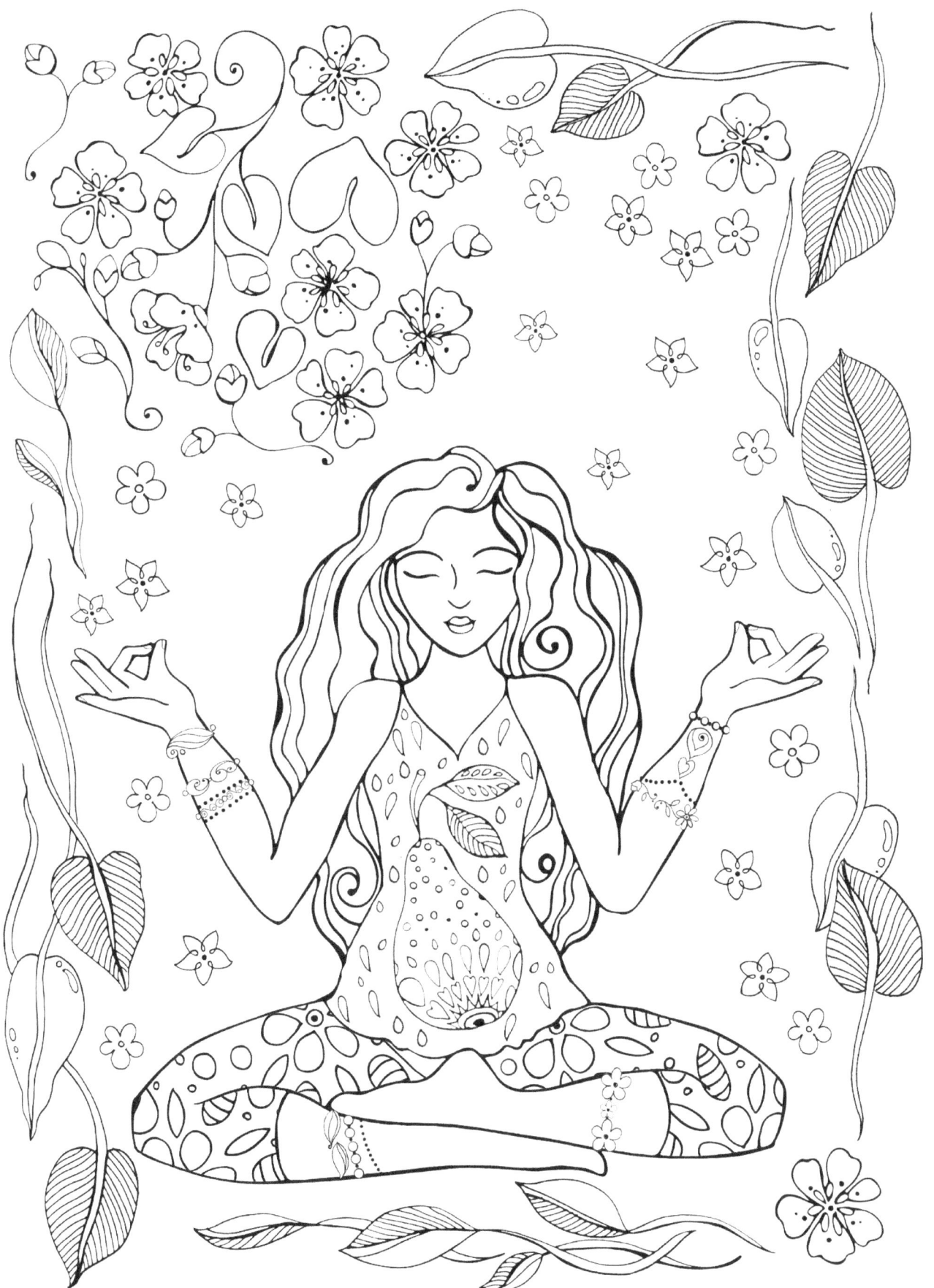

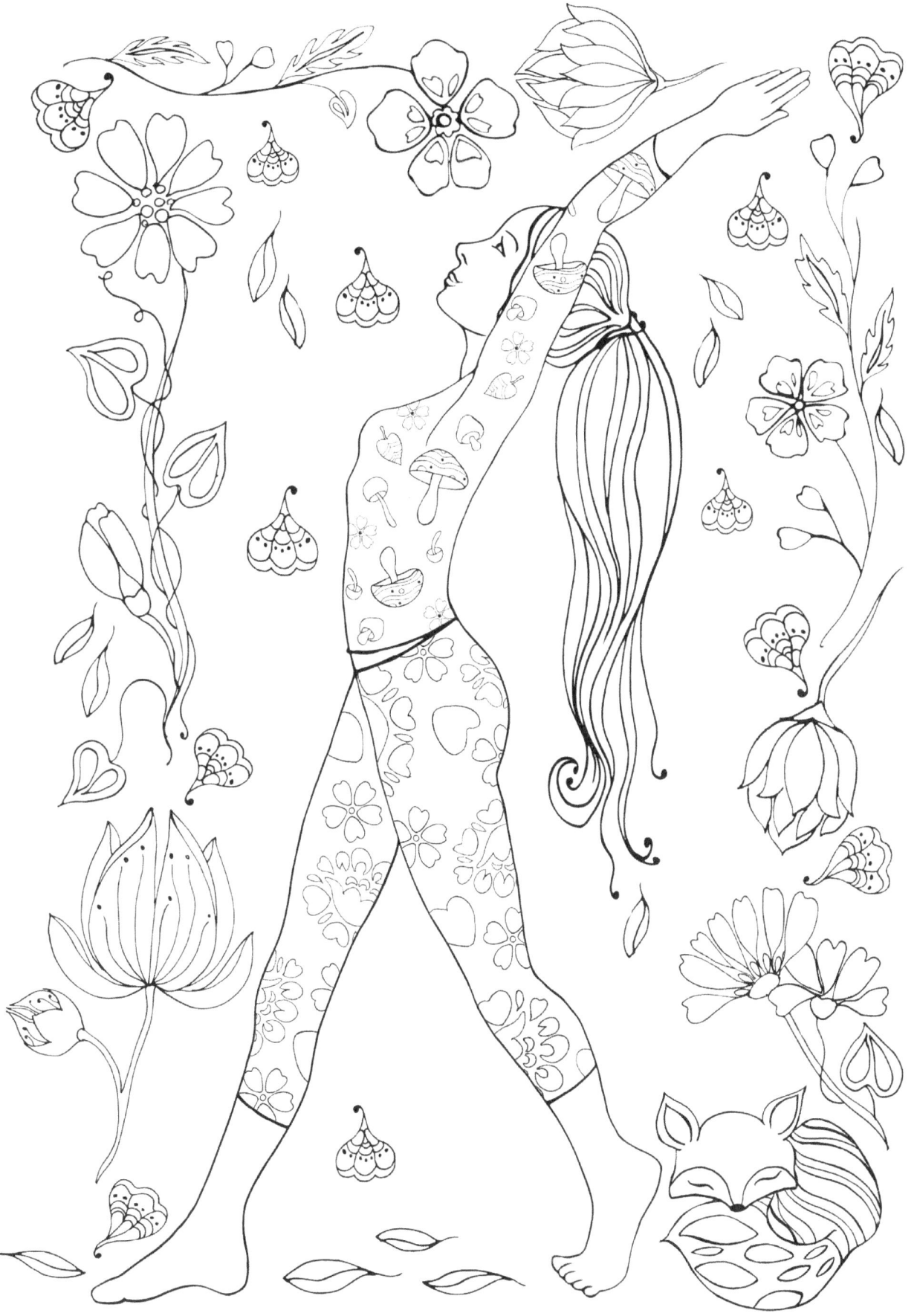

www.ingramcontent.com/pod-product-compliance
Lightning Source LLC
Chambersburg PA
CBHW081122180526
45170CB00008B/2971